How to Draw Manga for the Beginner
Step by step guides in drawing Anime characters

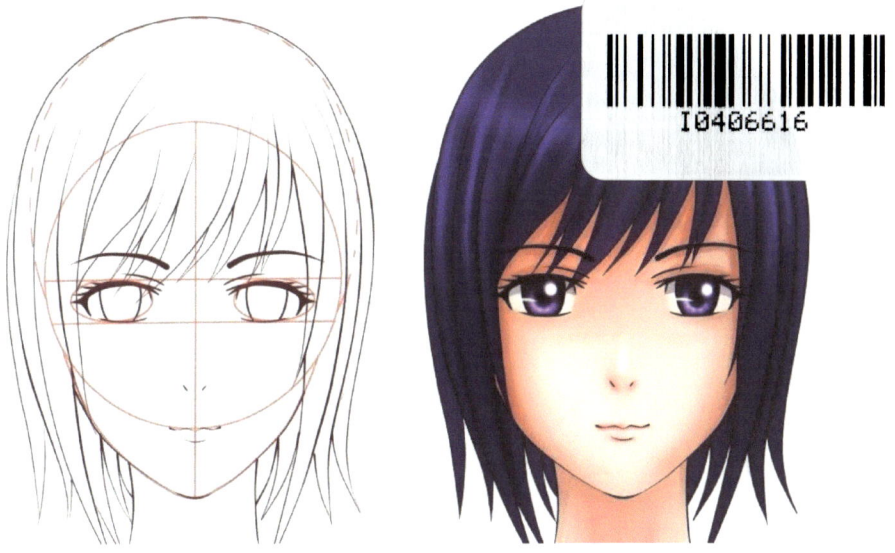

Learn to Draw Series

William T. Dela Peña Jr.

Mendon Cottage Books

JD-Biz Publishing

Download Free Books!

http://MendonCottageBooks.com

All Rights Reserved.

No part of this publication may be reproduced in any form or by any means, including scanning, photocopying, or otherwise without prior written permission from JD-Biz Corp and at http://JD-Biz.com.

Copyright © 2016

All Images Licensed

By: William T. Dela Peña Jr.

Learn How to Draw Books for the Absolute Beginner

Download Free Books!

http://MendonCottageBooks.com

Table of Contents

INTRODUCTION ... 4

Learning How To Draw .. 5

THE BASIC ELEMENTS OF DRAWING .. 6

 Lines ... 6

 Shapes .. 7

 Value .. 8

OVERVIEW OF A MANGA CHARACTER .. 9

STEP BY STEP DRAWING OF A MANGA HEAD 11

 Front View ... 11

 Quarter View ... 16

 Side View .. 21

DRAWING THE HAIR .. 27

THE EYES .. 38

DRAWING THE EARS ... 47

Drawing Manga Mouths ... 50

DRAWING MANGA POSES .. 52

COLORING MANGA CHARACTERS .. 57

Author Bio .. 76

Publisher ... 79

INTRODUCTION

Manga is a term for the drawing style developed by the Japanese that they use in their comic books. It has a distinctive look that separates it from the western comic style.

Because of its appeal to its viewers manga become popular throughout the world, many enjoy reading it because of the interesting plot of the story as well as the art and eventually manga evolved into an animated version called anime.

If you want to learn how to draw or if you just want to advance your skills in drawing manga, this book is perfect for you. This book features step by step instructions and includes some advanced techniques that will really help you improve your drawing skills.

Learning How To Draw

Many beginners struggle and loose their interest in drawing because of the following factors:

FIRST: SKIPPING THE BASICS

Many beginners jump into drawing without learning the basics. As a result, they end up with many questions in their mind that make them freak out and lose their creativity. Remember, the basics are your stepping stone to increase your skills and in order to become a great artist, you'll need a strong foundation that you can acquire in learning the basics first.

SECOND: THINKING THAT DRAWING IS HARD

Yes, Drawing is hard. Looking into a finished artwork is sometimes really intimidating. But drawing can be easy, just analyze the structures first and break it into its basic shapes and drawing is not as hard as many of you have imagined.

THIRD: LABELING ONESELF AS "TALENTLESS"

Drawing is just like learning how to write. So if you can write, you can draw. Remember the old days when you were starting to learn how to write: your lines are timid and shaky. The more you practiced, and the better you have become through the years. Drawing is also a skill that needs to be practiced and developed.

THE BASIC ELEMENTS OF DRAWING

These few elements of a drawing are the most commonly used. Having knowledge of it will help you understand how to draw Manga.

Lines

A line is made up of two points that connect each other. A drawing is made of a variety of lines (straight, curved, and zigzag)

In order to make your drawing more dynamic use a line that varies in width, this will make your lines more attractive as well as your drawing.

The picture above is a curved line that has no variety of thickness. It looks plain and boring while the picture below has a variety of thickness and looks more dynamic, doesn't it?

Shapes

 A shape is an enclosed space. It is limited to two dimensions: length and width. Geometric shapes are made up of points and lines which come from geometry while organic shapes are typically irregular or asymmetrical, it is associated with objects in nature.

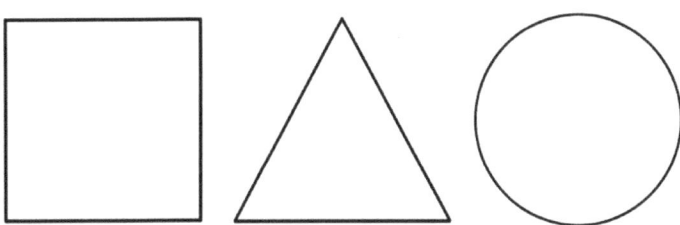

The pictures above are examples of Geometric shapes and the picture below are examples of organic shapes.

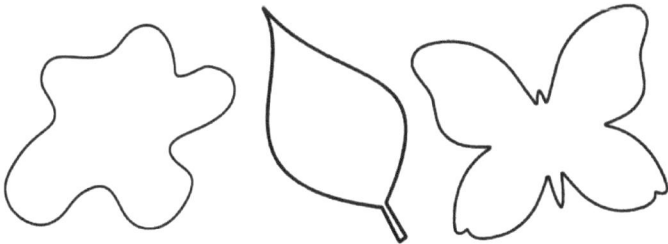

Value

Value is defined as the relative darkness or lightness of a color, value creates the illusion of depth which makes your drawing looks three dimensional. Having a vast knowledge in values will help you creating a great drawing.

Below is a picture of grayscale value.

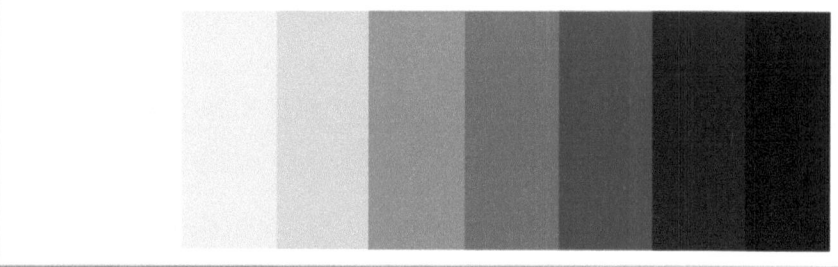

OVERVIEW OF A MANGA CHARACTER

Manga characters usually have a large stylized eye, small noses, tiny mouths, and sometimes a large head. The Female resembles larger eyes than males and have a thinner neck and smaller chin and also the shape of the face differs from each gender, female heads are made up of smooth curves and tends to have a semi-rounded shape, while males have an angular shape of the face.

When drawing your character in a childhood stage, the rules that I mentioned earlier doesn't imply, during the childhood stage opposite genders can share similar features only differing in their hair style.

STEP BY STEP DRAWING OF A MANGA HEAD

Guidelines in a drawing are important to ensure the proportion and proper placement of the features of the face.

Front View

Step 1: Draw a circle and draw a vertical and horizontal line at the center of the circle as shown the figure below. *(fig. 1)*

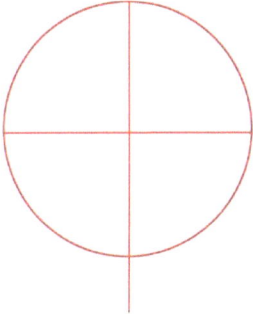

fig. 1

Step 2: Draw a line to the side of the circle that connects to the end point of the vertical line and connect it to the opposite side. *(fig. 2)*

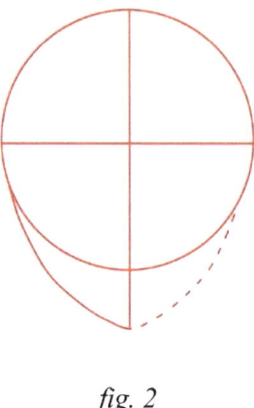

fig. 2

Step 3: Draw a line below the center of the circle this will serve as the height of the eyes. *(fig 3)*

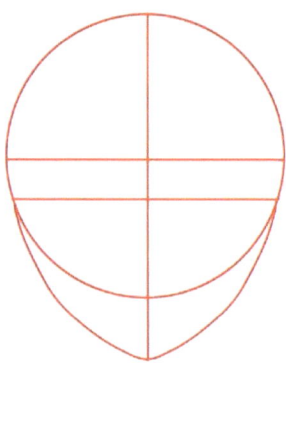

(fig. 3)

Step 4: Draw an oval in the center of the circle that will occupy the eyes, this will be your reference area for the eyes and it also serve as the distance. *(fig.4)* then copy the oval on both sides. This is your guide in placing the eyes *(fig.4a)*.

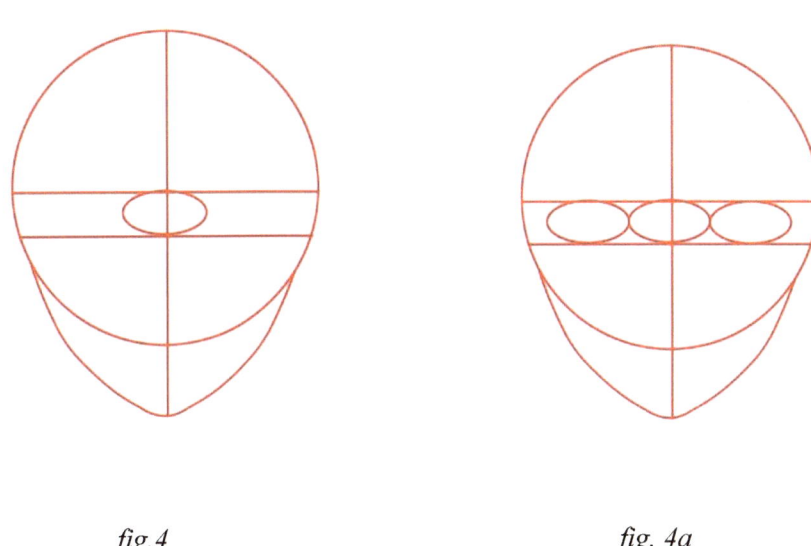

fig.4 *fig. 4a*

Step 5: Draw a dashed curve line at the top of the circle this will serve as the borderline of the hair. *(fig. 5)*

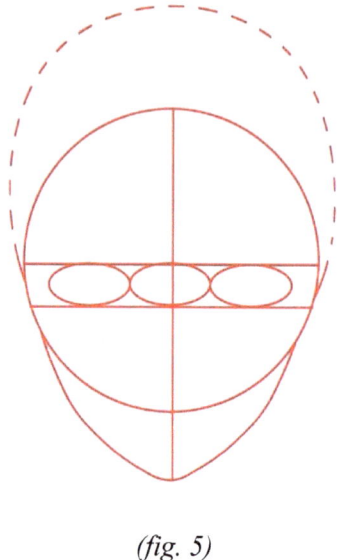

(fig. 5)

Step 6: Then draw the facial features. After you finish it remove, the guidelines.

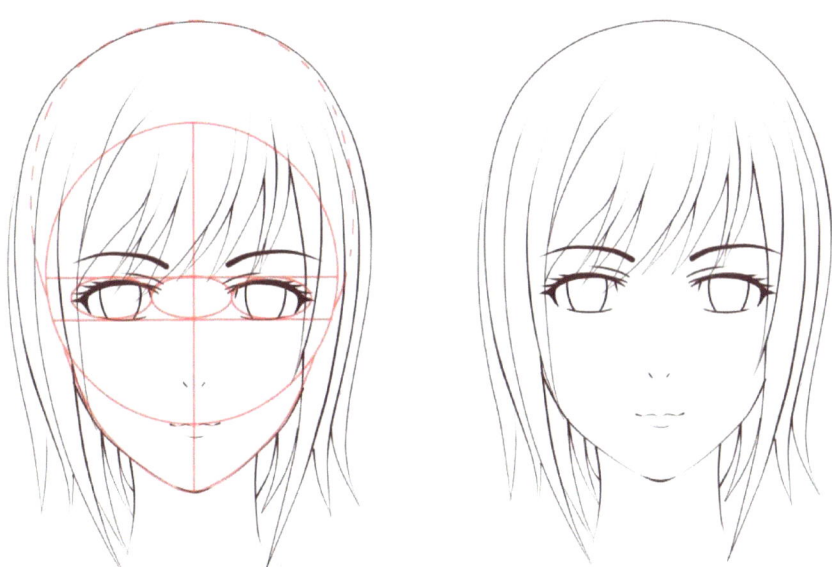

Quarter View

1. Draw a circle and place vertical line slightly to the left corner of the circle. (*fig.2a*) then draw a horizontal line at the center of the circle (*fig. 2a1*).

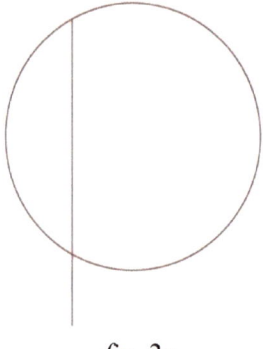
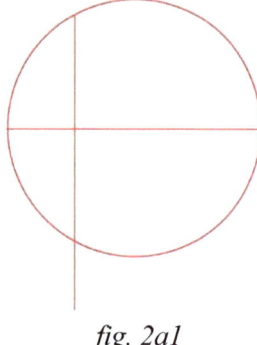

fig. 2a *fig. 2a1*

2. Then draw a line that connects to the end point of the vertical line. Make it a slightly curving to indicate the contour of the face, then repeat it to the opposite side. (fig. 2a2)

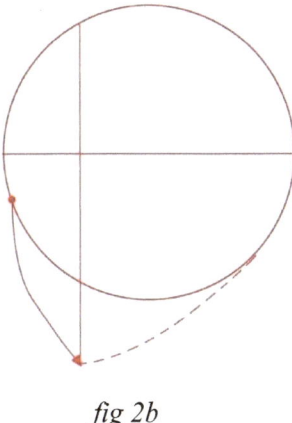

fig 2b

3. Draw an oval, slightly at the center of the circle. (fig. 3a) then draw another oval to the left, this time, make the width of the second oval shorter than the first oval, but don't reduce the height and make the alignment slightly lower than the first oval. (fig. 3a1)

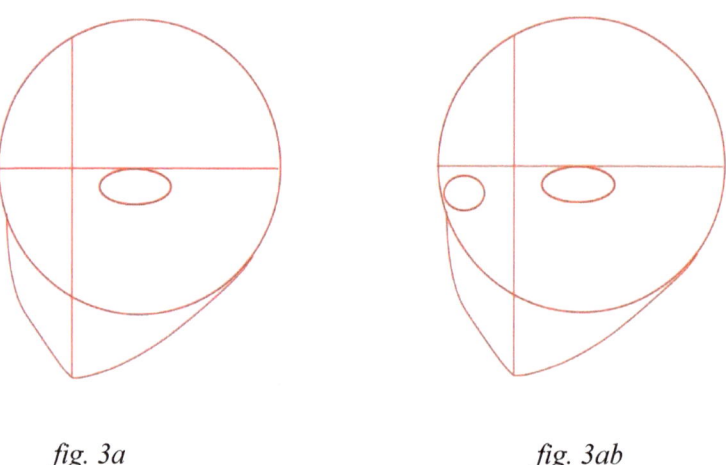

fig. 3a fig. 3ab

4. Draw a dashed curve line that at the top of the circle that covers the head. This will be the borderline of the hair. *(fig. 4a)*

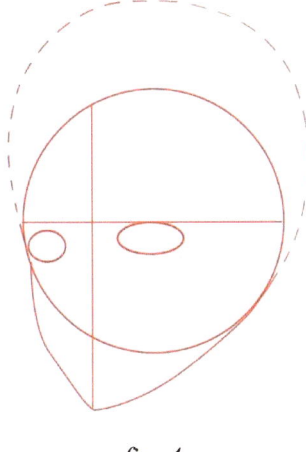

fig. 4a

Step 5: Then draw the facial features and remove the guidelines.

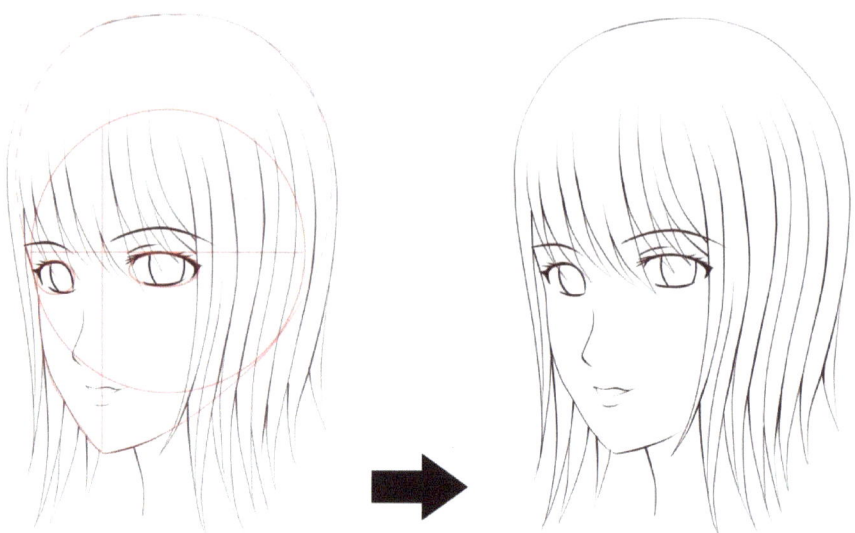

Side View

1. Draw a circle and draw a vertical line at the center of the Circle. *(fig.1)*

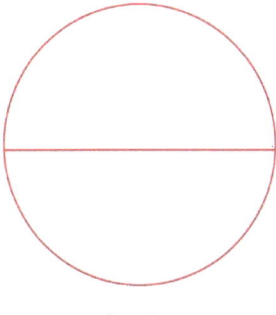

fig. 1

2. Draw a slanting line to the side of the circle. *(fig. 1a)* then draw a line that connects outside of the circle below *(fig. 2a.)*

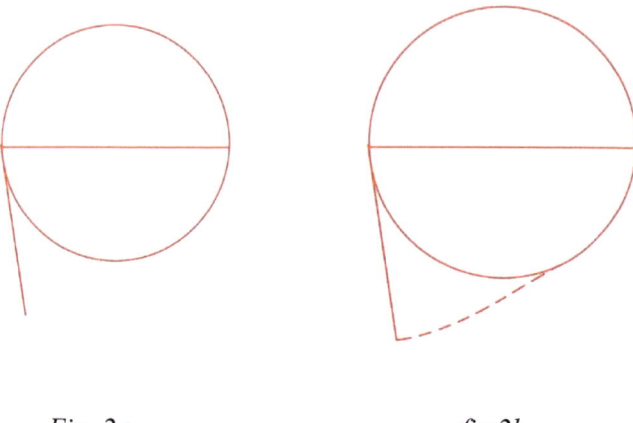

Fig. 2a fig. 2b

3. Draw a triangle as shown in the figure below *(fig. 3)*. This will be the area where you will place the eyes.

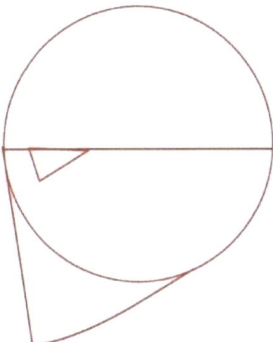

4. Then draw a dashed line at the top of the circle this will serve as the borderline of the hair. (fig. 4)

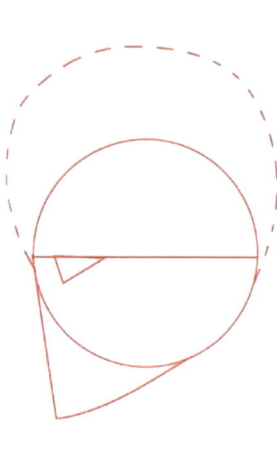

fig. 4

5. Then draw the facial features. (fig. 5)

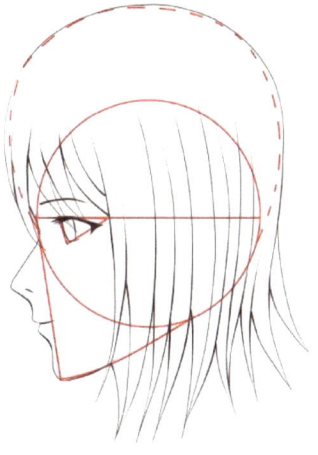

fig. 5

6. Finally, remove the guidelines.

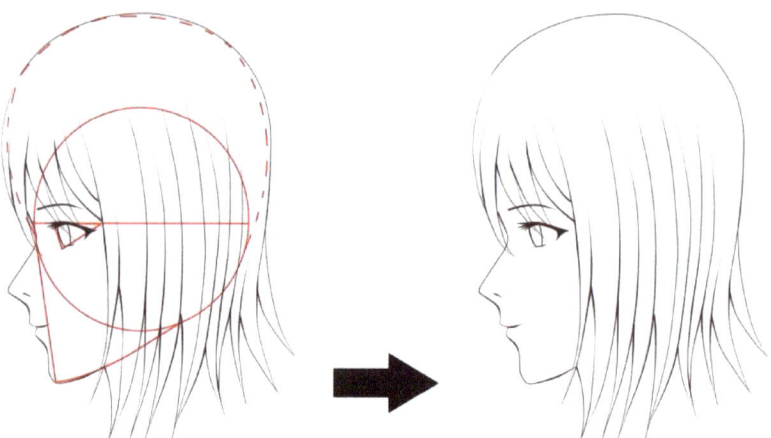

DRAWING THE HAIR

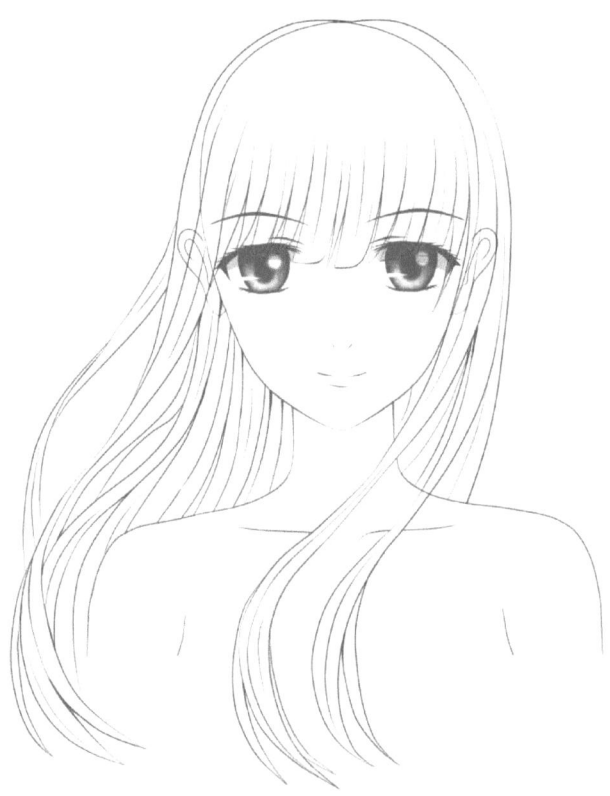

 In manga drawing the hair also has a unique characteristic. Manga characters have fluffy hair with sharp edges and is sometimes separated by many lines.

 Drawing dynamic hair could possibly be hard for a beginner at first. But by these techniques that are included in this tutorial, you can learn how to draw dynamic, natural looking hair.

Practice drawing curves, these will help you to prevent your hair drawing to look stiff. Having stiff looking hair will mess up your drawing so pay attention in drawing the lines that will make up the hair.

To get a dynamic flowing line work, hold your pencil or pen loosely and aim to draw in slanting position, also, utilize the tip of your pencil or pen to make a variation of width, fill in 1 page or more and do this until you achieve dynamic looking line work.

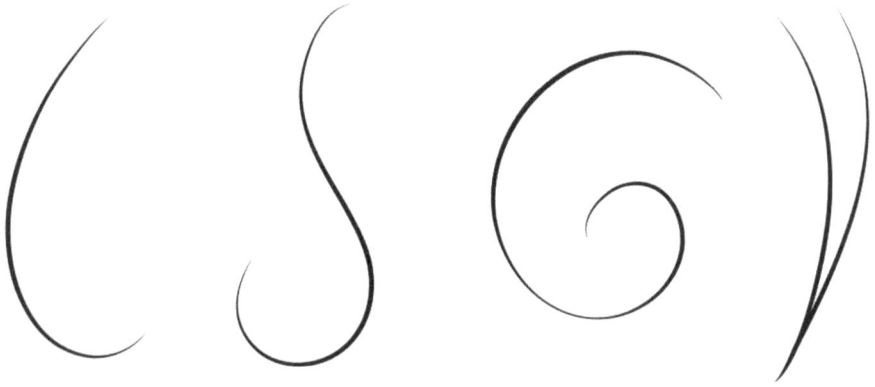

Don't make the width of the hair consistent, this will result in noodle looking hair instead of a nice flowing hair

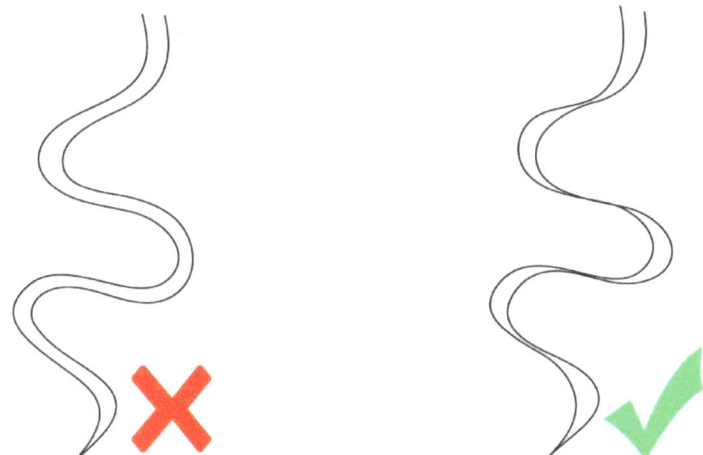

Hair also makes some overlaps. Pay attention to how overlaps are created, they are encircled in the color red.

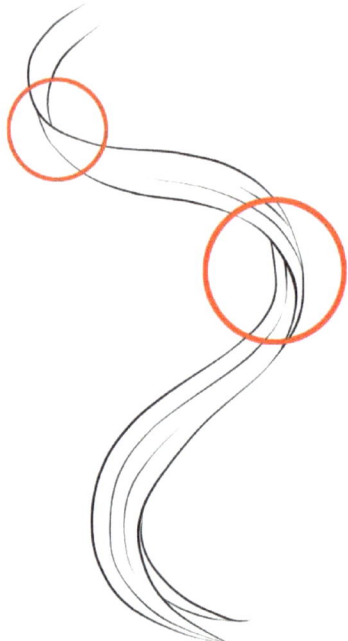

Don't make uniform strands, it looks boring and doesn't look natural, instead make random strands that vary in thickness.

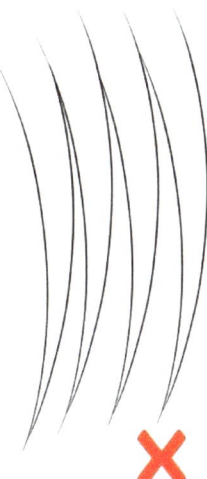
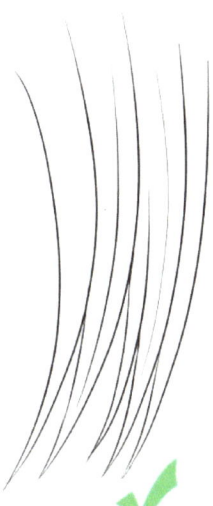

To begin, decide a point of origin, this is where the flow of hair will start. The red dot represents the point of origin.

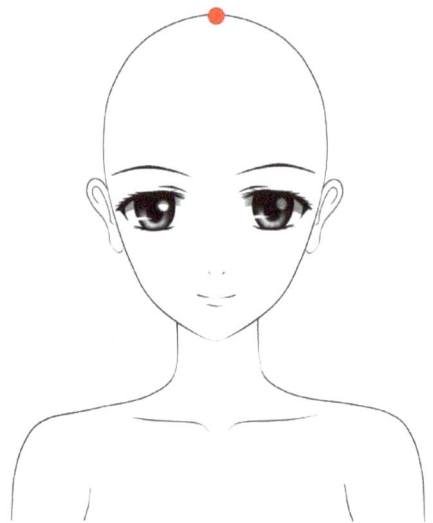

The blue dashed lines represent the direction of the flow of the hair. The direction of the flow can be changed by matter acting on it, one example is the wind that may blow the hair.

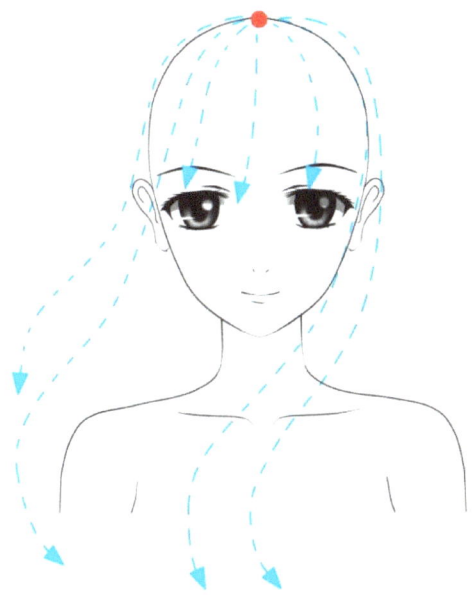

Draw the basic volume of the hair and apply the techniques in drawing hair that I mentioned earlier in this tutorial.

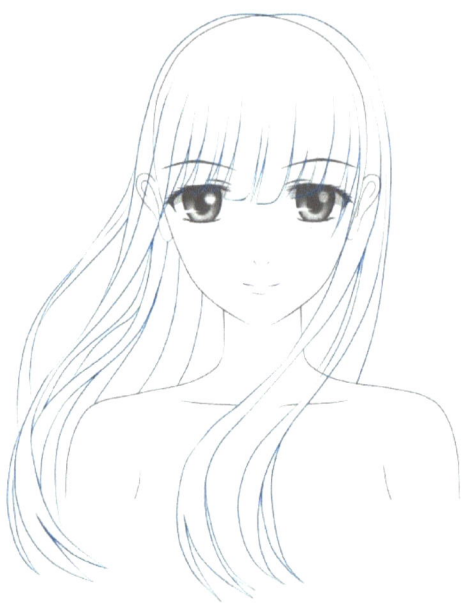

Finally, add some random lines to make it more detailed and look natural.

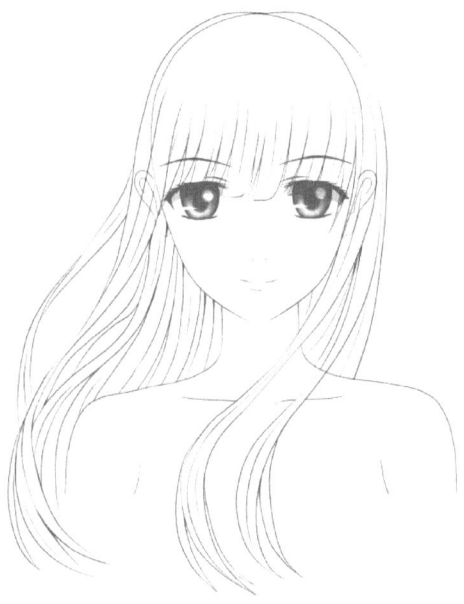

Below, are samples of manga hairstyles, there are many different hairstyles so don't limit yourself with just a few hairstyles. Try to experiment and create unique hairstyles.

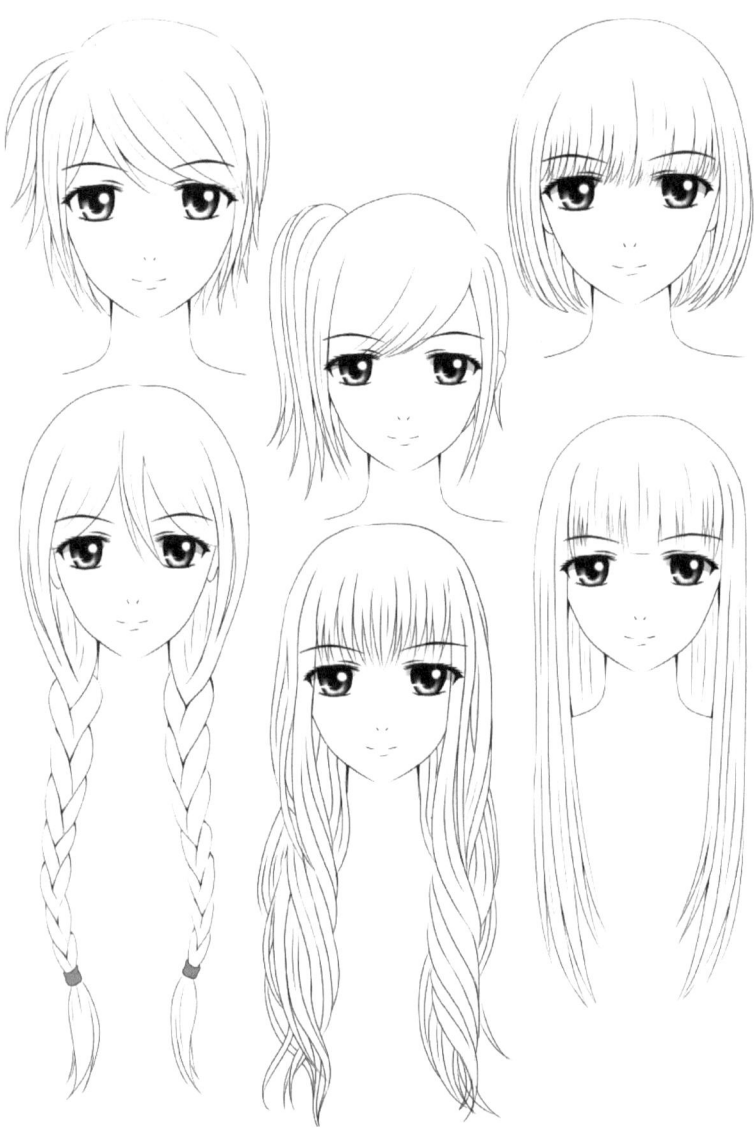

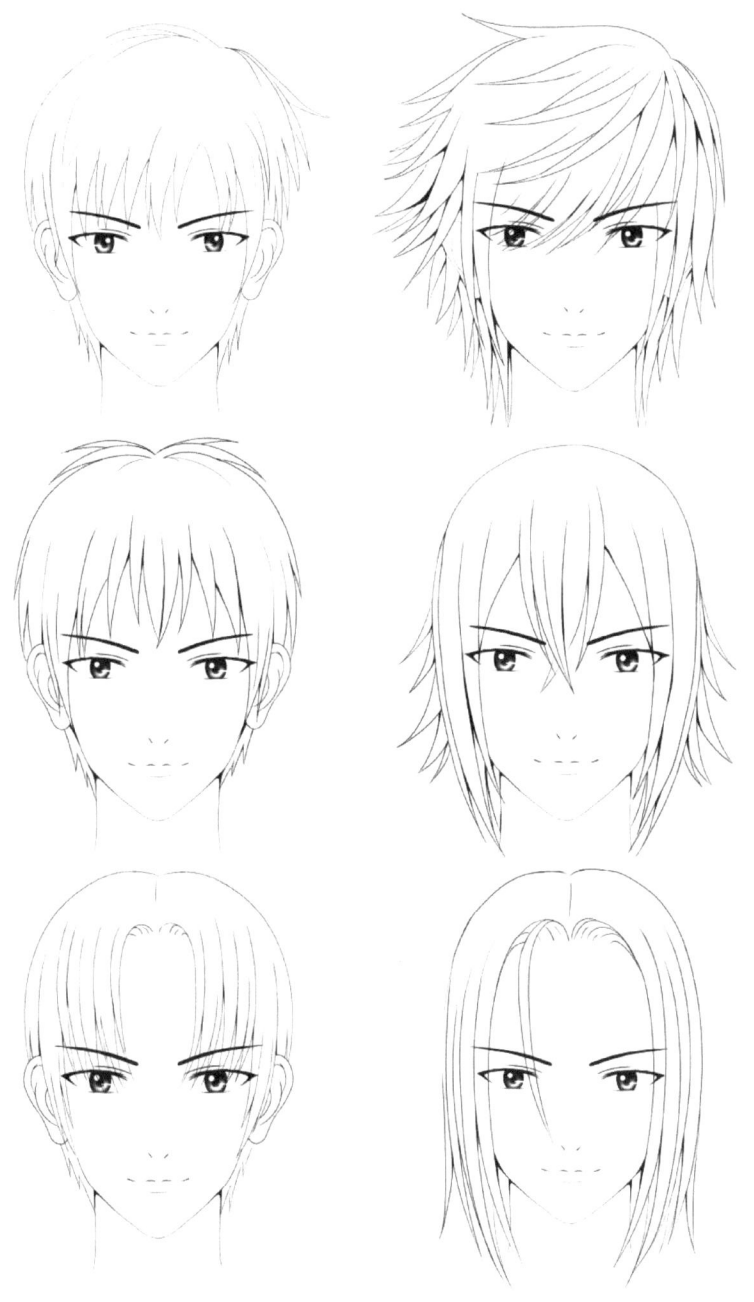

THE EYES

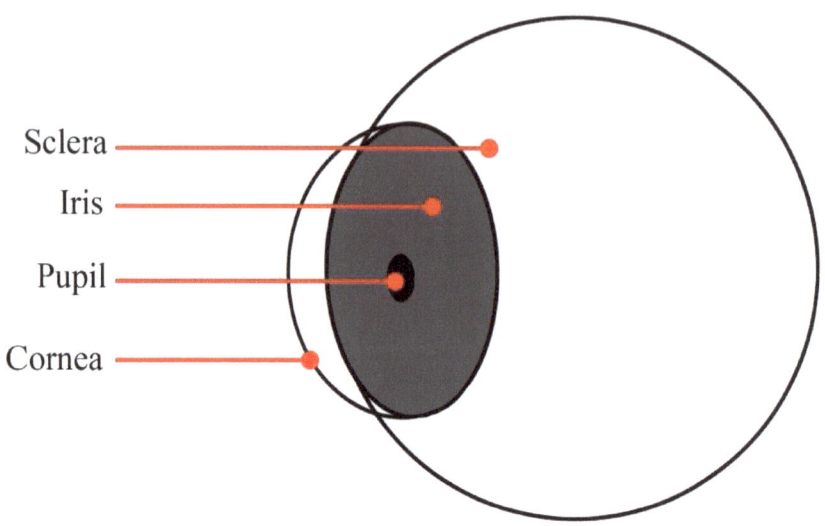

 Before we go in depth in drawing the eyes, let's have a short review of its anatomy. Learning the basic anatomy of the eye will help you to understand how to draw it accurately.

The **Sclera** is basically the white part of the eye.

The **Iris** is the colored part of the eye. In manga style, the iris is the most important feature, if you look at a manga drawing the iris takes up the majority of the eye space.

The **pupil** serves as the light receiver and in manga style putting a pupil is just optional.

The **Cornea** acts as the eye's outermost lens. It is transparent and filled with liquids that make the eye shine.

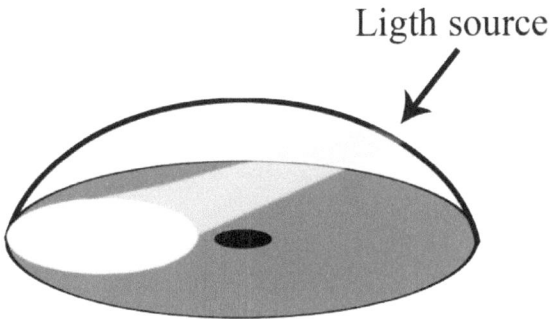

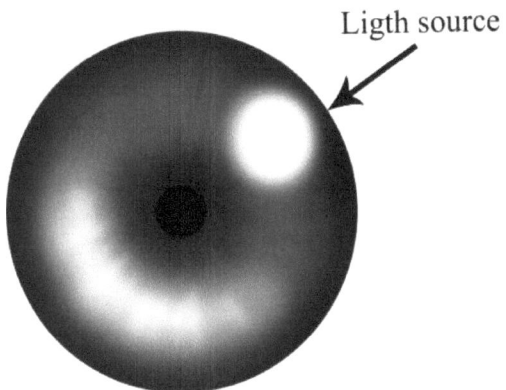

This shows how the cornea reacts to the light source. The upper drawing represents how the light enters into the cornea and how its direction changes. Below the upper drawing is a realistic iris that represent how it looks in real life. Overall, the simple key is where the light goes the opposite side will lighten up.

Though manga drawings are not so realistic, the principle of the anatomy of the eye in real life implies. So learning the anatomy of the eye is a great tool in stylizing your manga drawing.

In manga style, the eye is a little bit different from normal. The eye is the most noticeable feature so you must set your focus in drawing them. There are many ways to draw manga eyes. Below is the one of the methods by which I draw them.

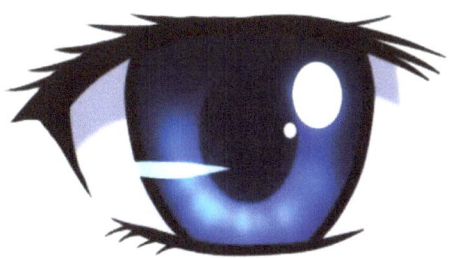

Step 1: Draw a curve and make the left end thicker than the right and also make the level of both ends not the same.

Step 2: Draw a slanted curve on both sides and notice how the curves are created below.

Step 3: close the gap by drawing a curve line below

Step 4: Render the lines by adding thickness to it and add also a pointy inverted triangle to the left side of the drawing, notice how the rendering goes below and finally put some eyelashes.

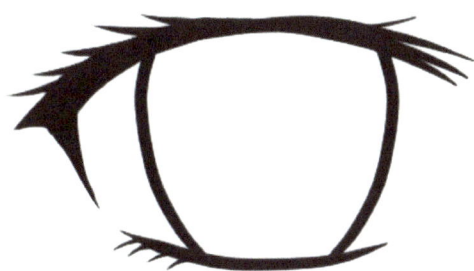

Step 5: Set the base color. You can choose any color of the iris and make the sclera have a tint of least amount of purple or blue or if you want, you can just use the normal color which is white.

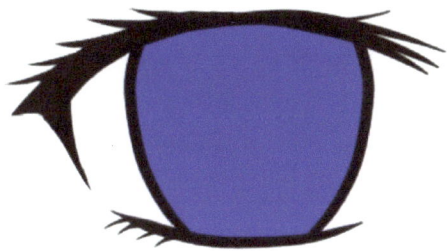

Step 6: Make a gradation of the base color and the darkest value of it, apply it mostly to the upper corner and around the edges.

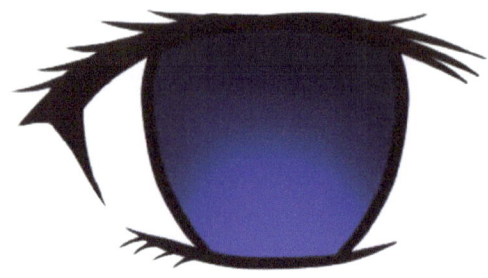

Step 7: Then draw an oblong at the center and filled it with a dark color.

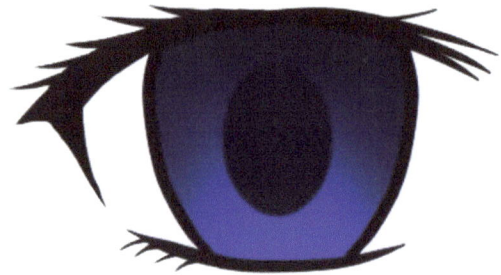

Step 8: Put a highlight. The placement of the highlight depends on the light source you set.

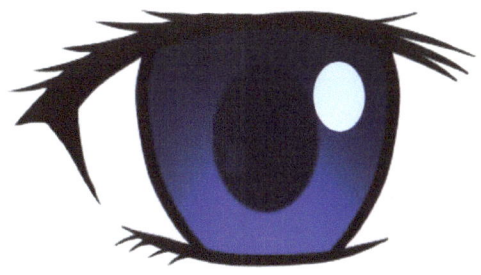

Step 9: Lighten up the opposite side where the source of light goes use a lighter color related to base color that you set.

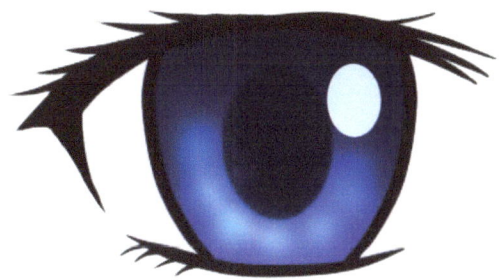

Step 10: Draw some additional highlight to make it look watery because basically the cornea of the eye is filled with liquid. Finally, put some dark shade below to the upper lid because basically in real life upper eyelid casts a shadow on that area.

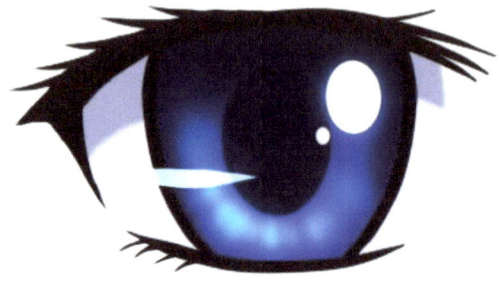

DRAWING THE EARS

Below is the picture of an ear and its anatomy details, by knowing the basic anatomy of the ears you can draw them with ease and accuracy.

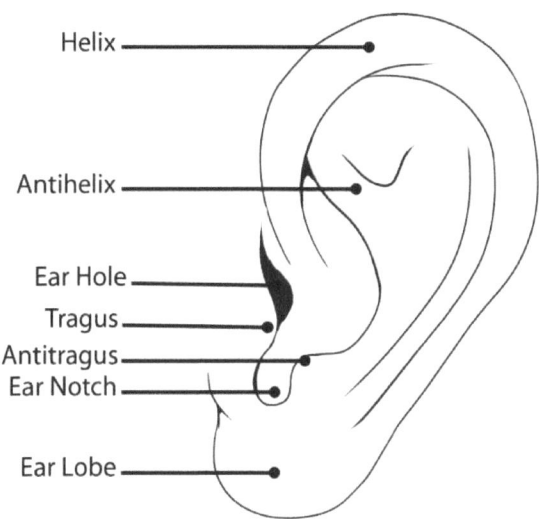

The **helix** resembles a question mark outside the perimeter of the ear. Below the Helix is **Antihelix** it resembles the letter "Y".

The **Ear hole** is located at the center left of the ear and below the ear hole is a node called the **Tragus** and across the tragus, there is another node called the **Antitragus** between the triggers and antitragus there is a hole called **Ear notch.**

Below are the picture of the ears in three different views, in manga style it is not necessary to draw ears in complete anatomically correct detail we will simplify it by removing some details.

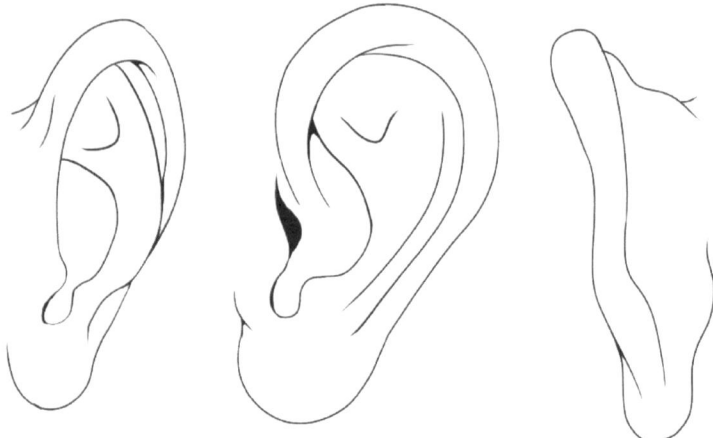

Below are the simplified versions.

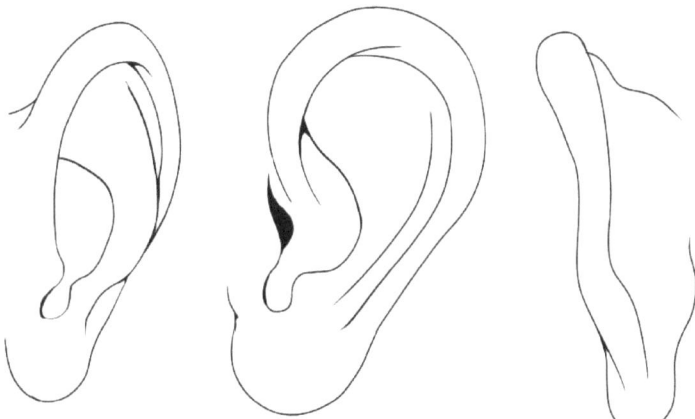

Drawing Manga Mouths

In the manga style mouth is often comes with exaggeration to accentuate the mood of the character.

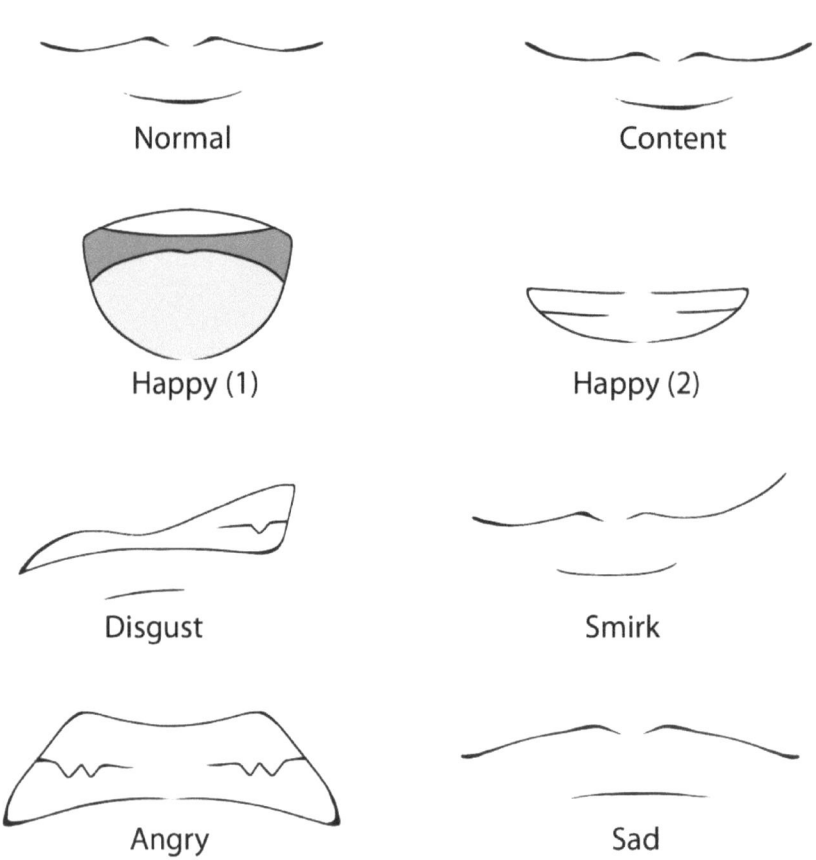

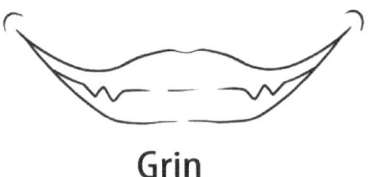
Grin

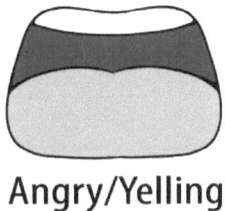
Angry/Yelling

Scared

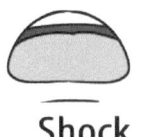
Shock

Shy/Embarrased

DRAWING MANGA POSES

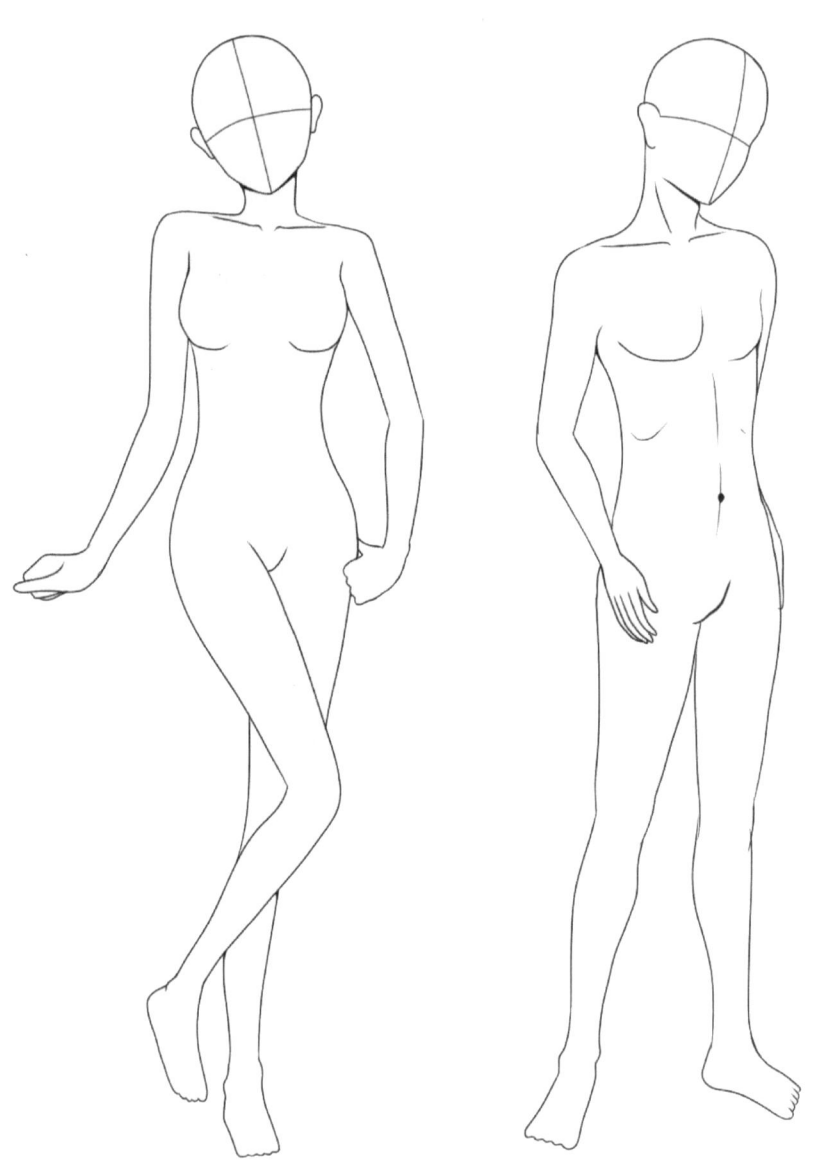

Step: 1 Establish a line of action

The Line of action is an imaginary line that runs through the head down to the lower part of the body. The line of action is the key to making your character pose's look more dynamic and not stiff.

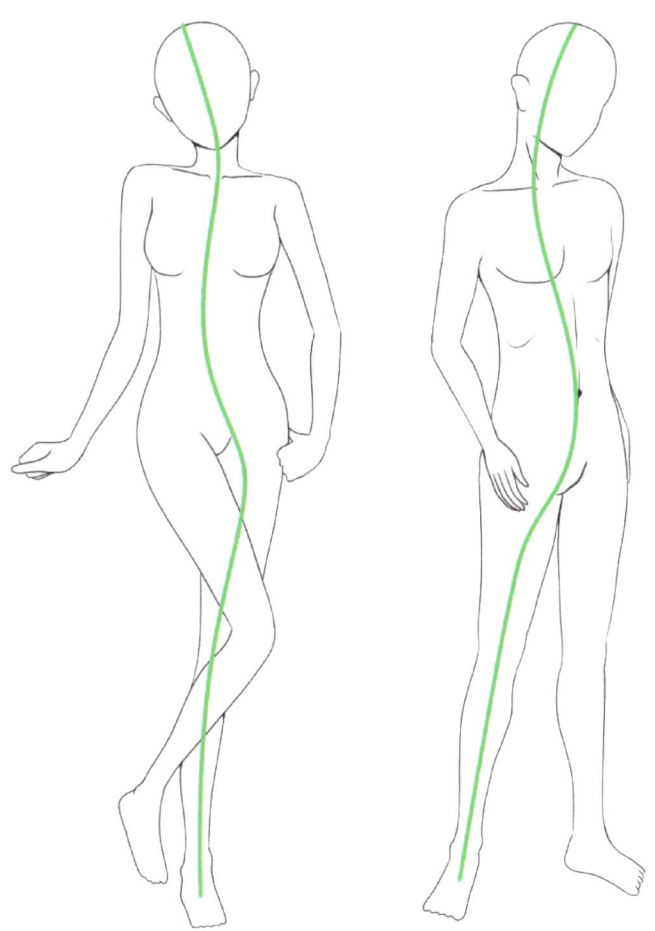

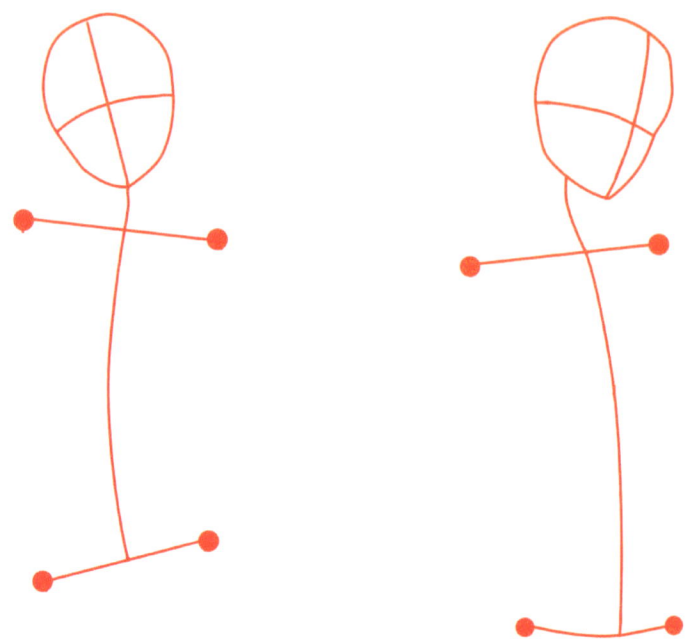

Another tip is not using a straight line when drawing the spine unless it is on the front view use a flowing line instead, and also, make the angle of the hips and the shoulder opposite to each other this will make the pose more interesting.

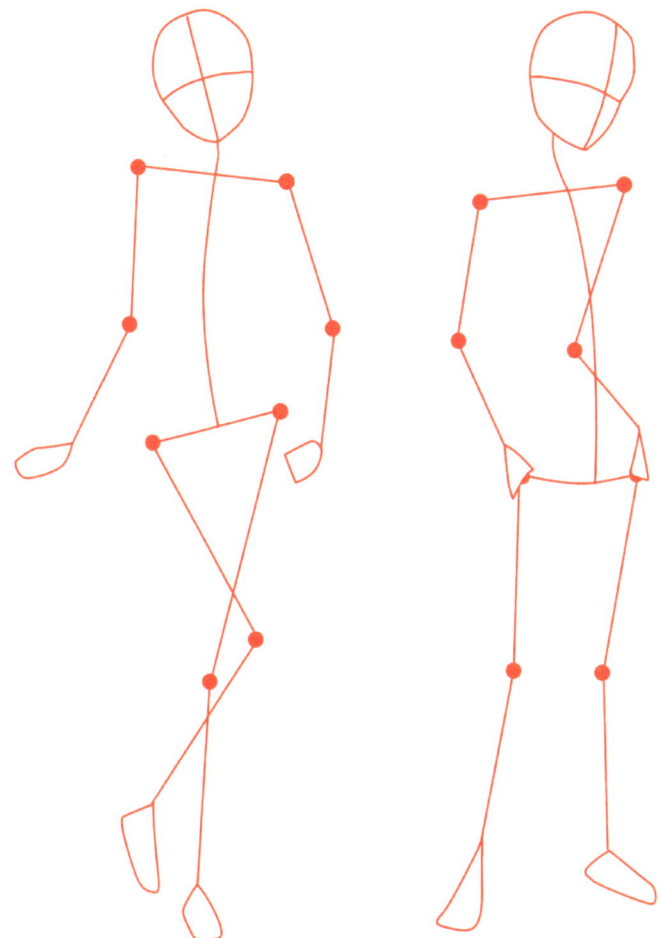

Step 2: Start with the basic stick figure.

Stick figure will serve as the wire frame of the pose, in this stage don't think about the mass and contour of the body. Indicate the joints by putting a dot as a landmark and break the shape of the hands and the feet into its simplest shape.

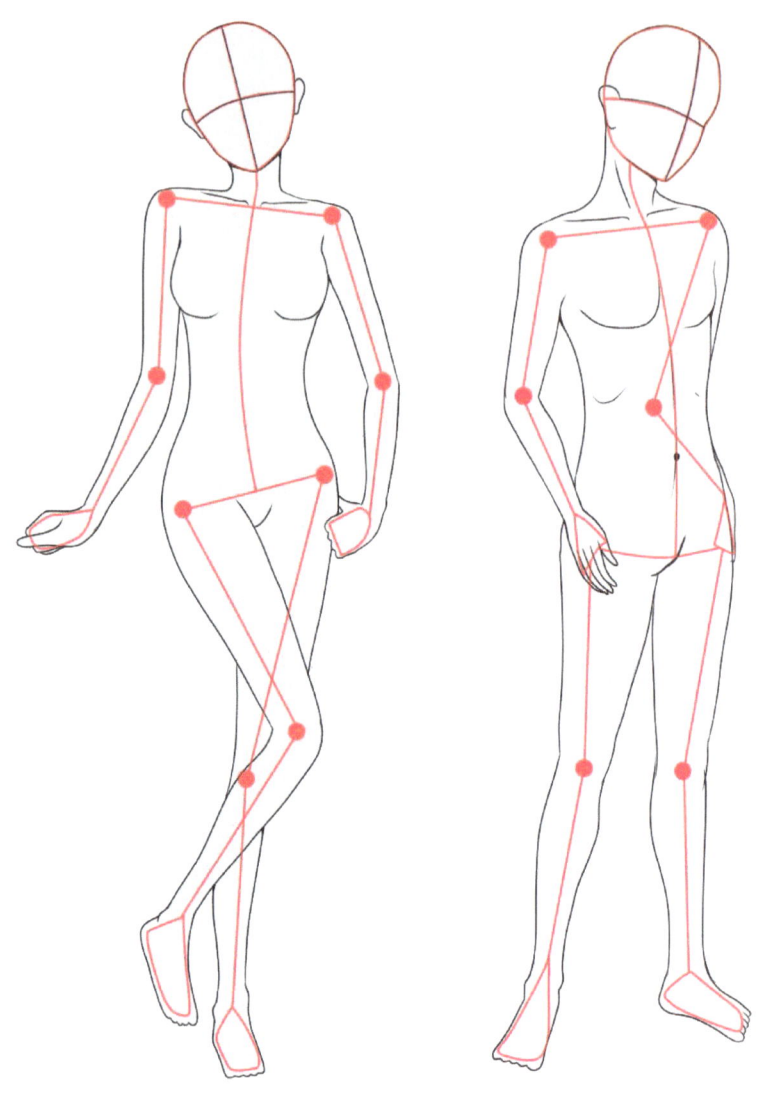

Step 3: Lastly draw the mass and contours of the pose.

This is the final stage of drawing a pose after adding the mass and contour remove the stick figure because you'll no longer need that then start filling the pose with details.

COLORING MANGA CHARACTERS

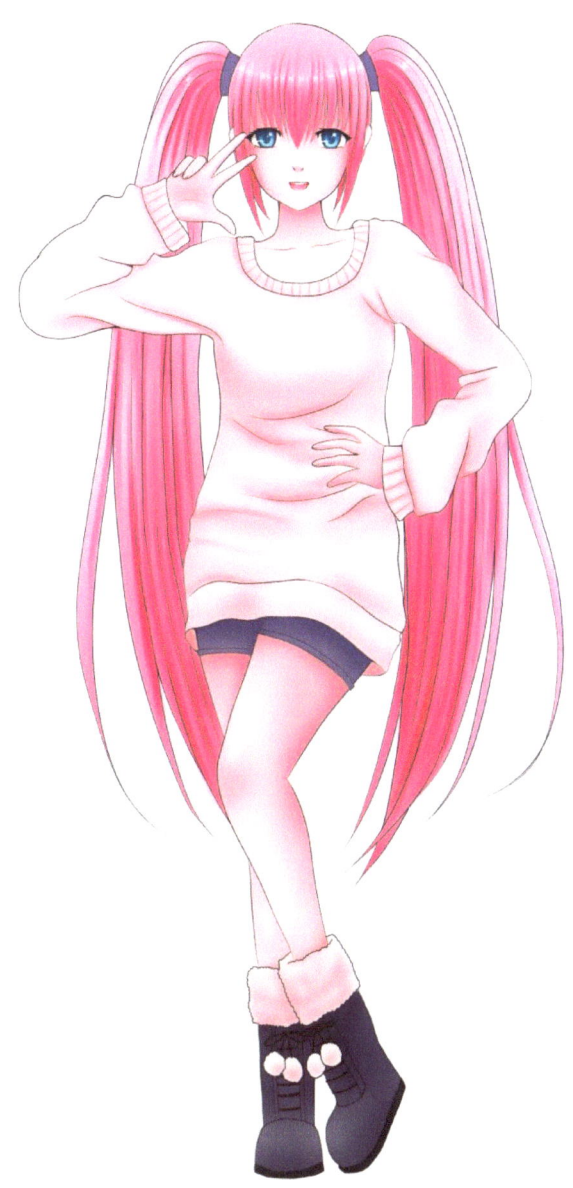

In this tutorial, I will demonstrate my method of how to color a manga character. I use a technique that is similar in traditional media while working digitally. I use Manga studio Ex5 but you can use your preferred software. Start with a base color, choose a color that is not too dark and not too bright then set a light source. In my case, I set the light source at the top center.

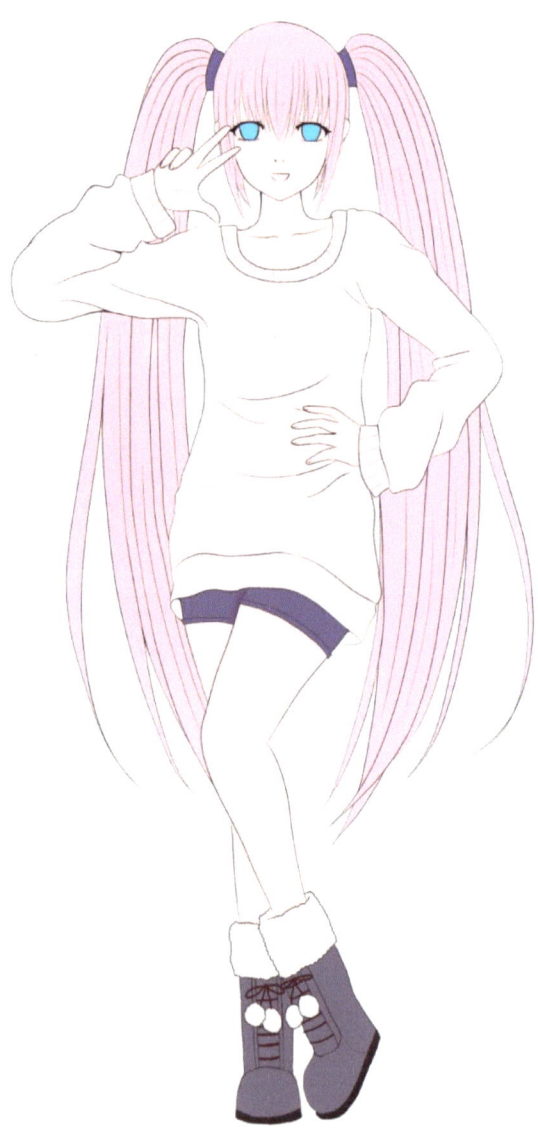

When shading focus only on a certain part to have a organize workflow. I shade the hair first and I start with just minimal shading first, I select a darker color of the hue of the base color of the hair, then I use a soft brush to make a soft gradation.

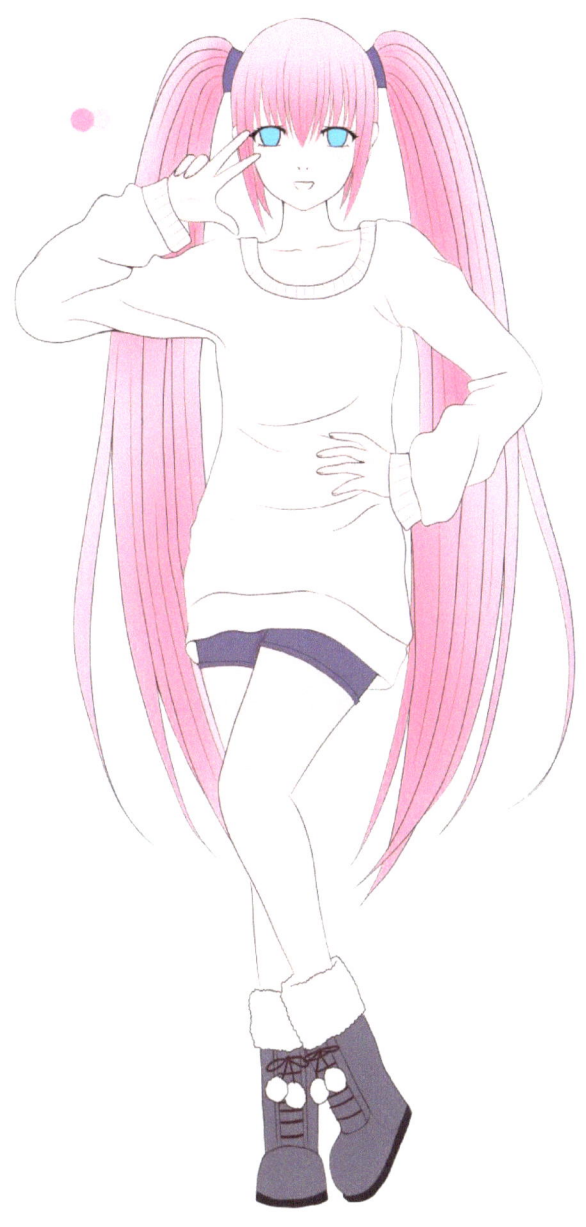

Then I add an additional shade that is relative to the hue of first shade.

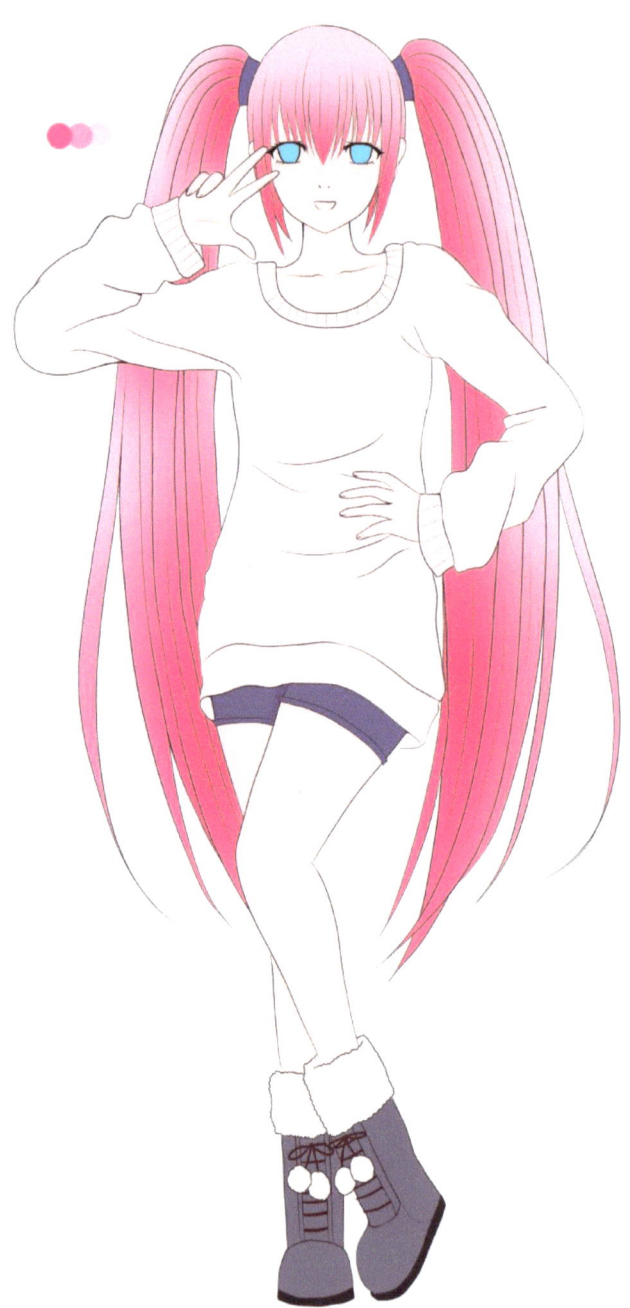

Then I draw some lines to define the details of the hair I use a hard brush to do this.

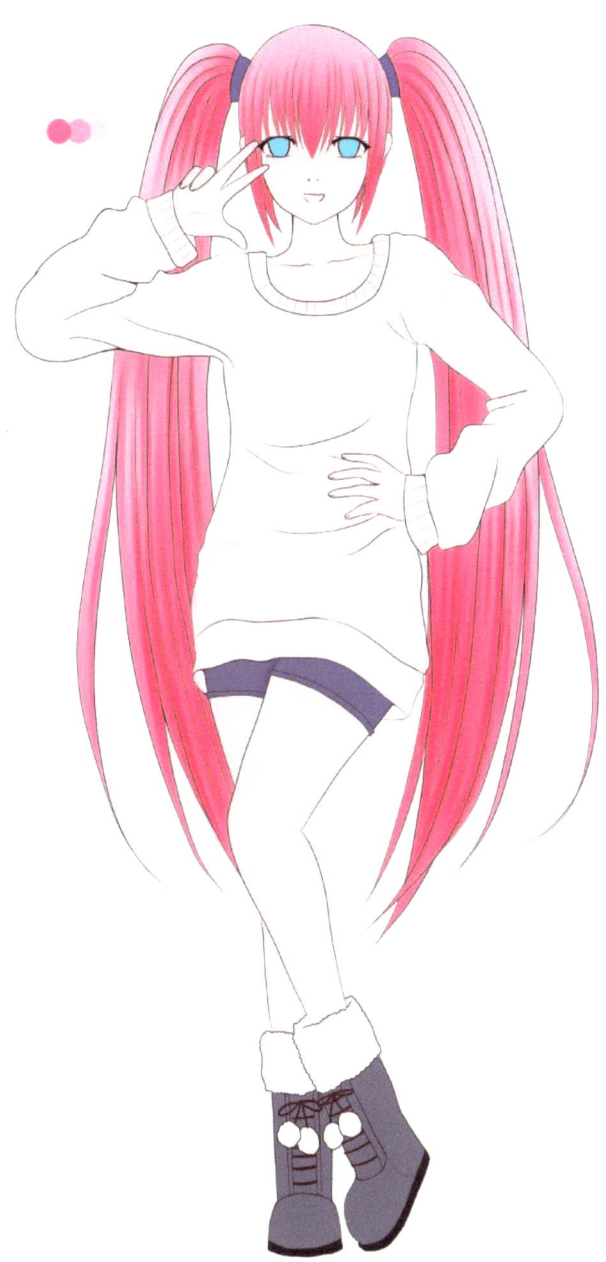

Then again, I select a color that is darker than the color of the previous shade, then I draw some lines to define more depth in the hair.

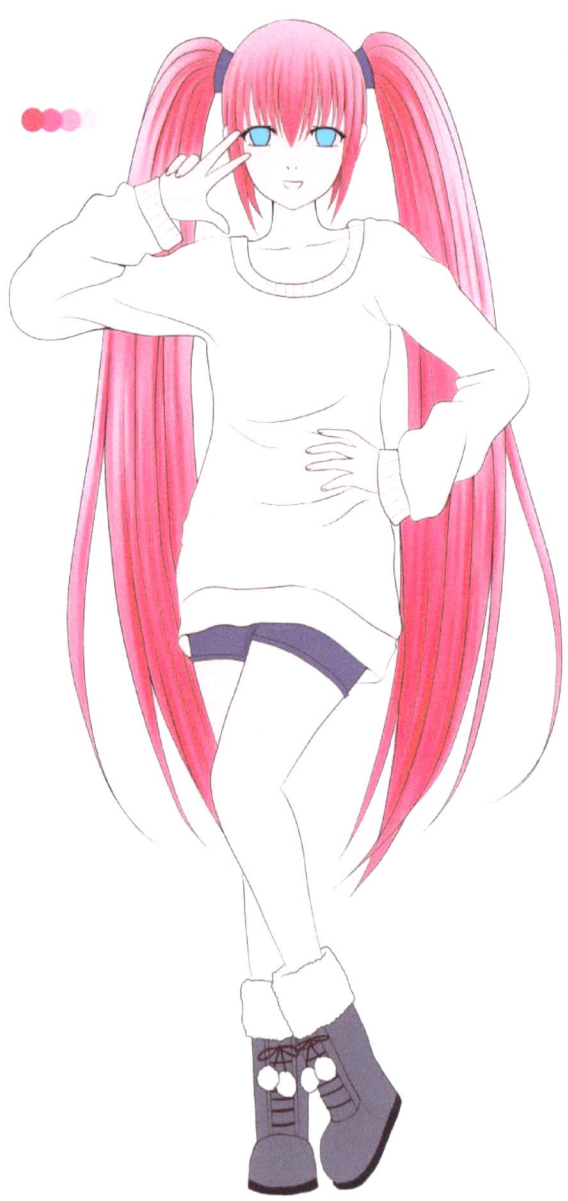

Then I lighten up some areas of the hair, I use a soft brush to do this. I set the layer to add glow. If you're working in photoshop set the layer to Linear dodge or screen.

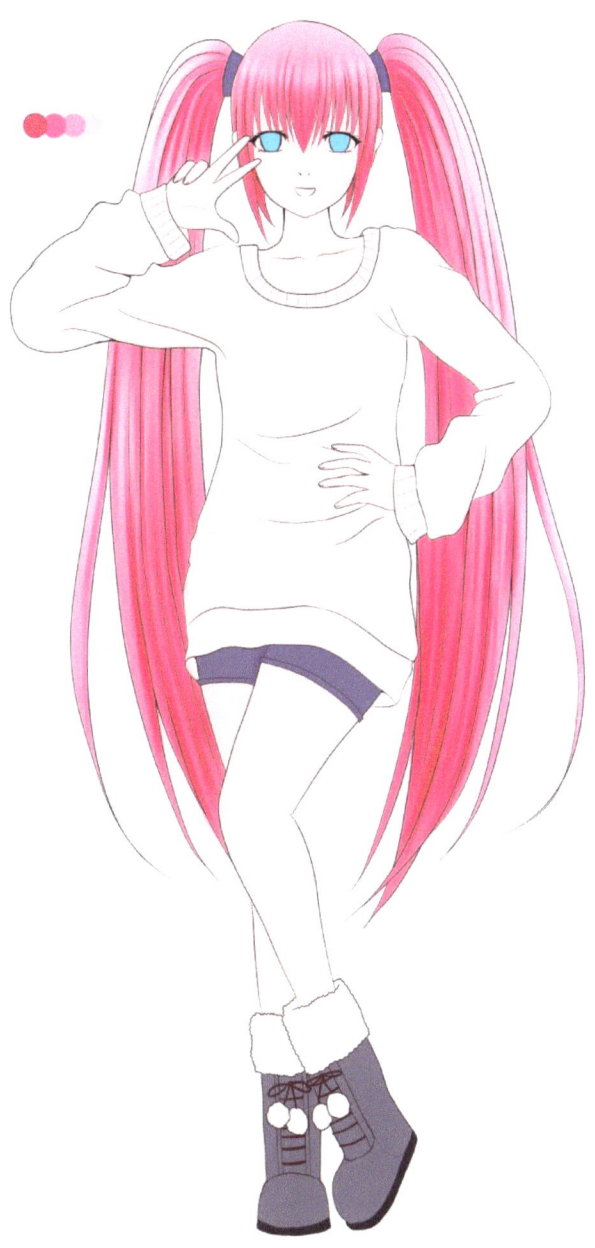

Then finally I added highlights by drawing some random lines and this makes the finishing touches.

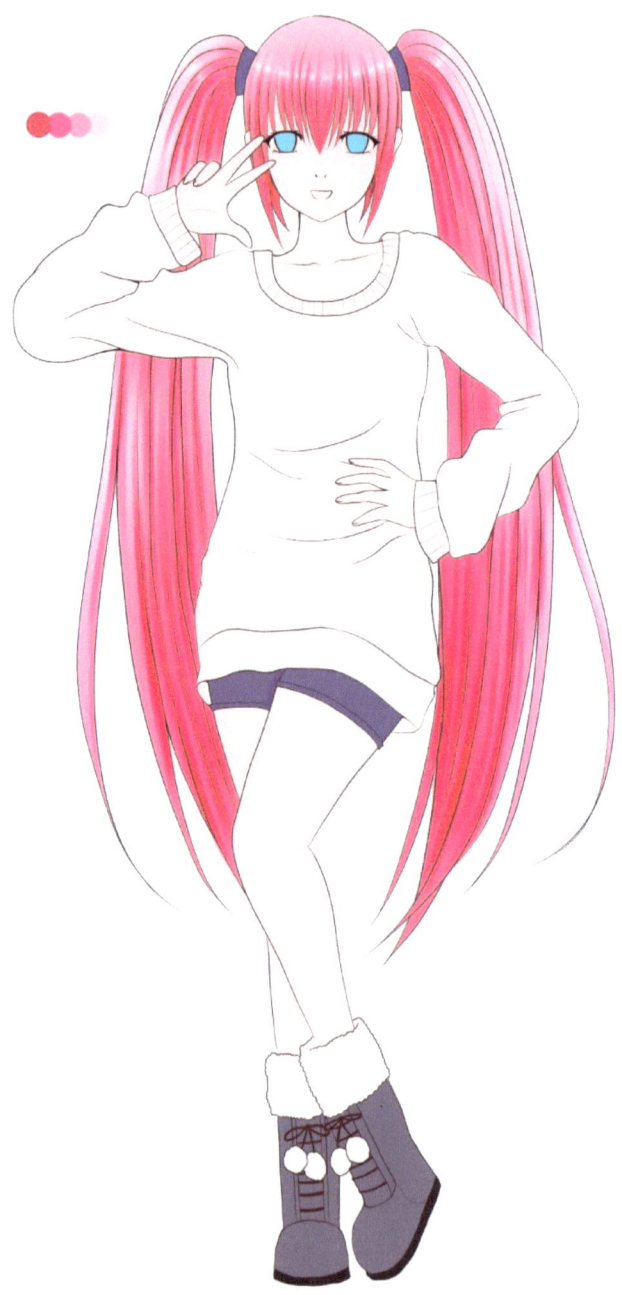

Now for eye detailing, first I create a gradation of the base color of the eye and its darkest value.

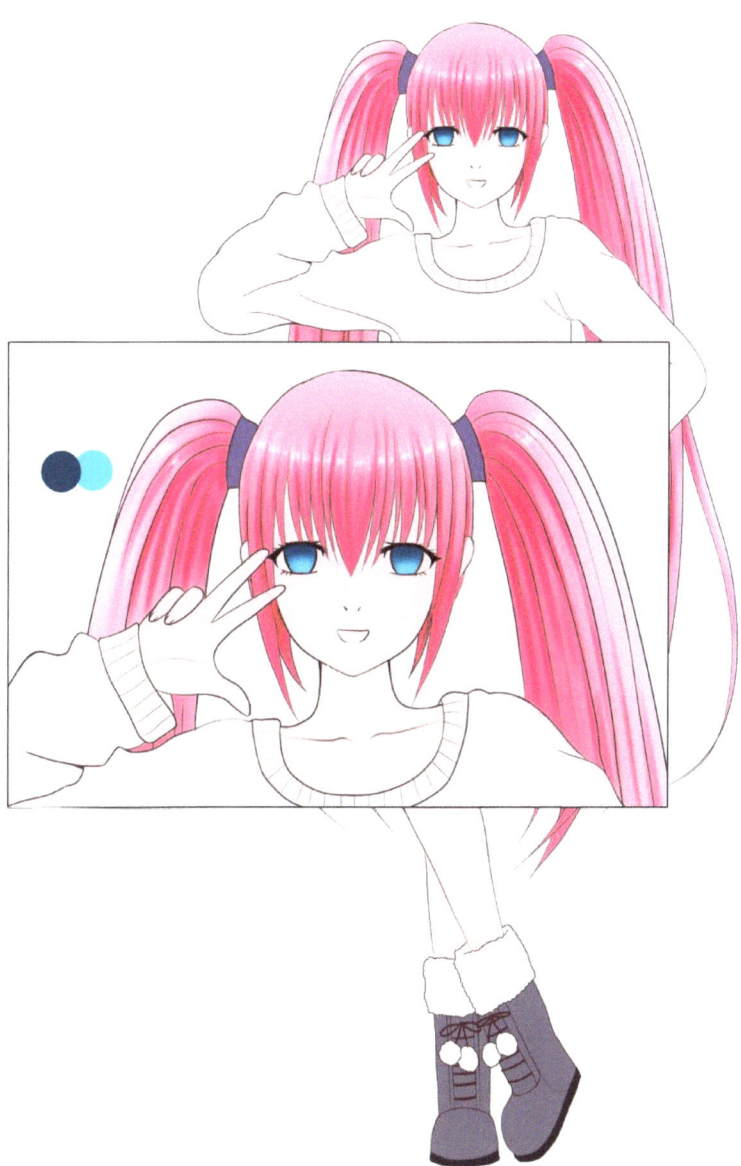

Then I draw an oblong inside the eyes with the color of the darkest value of the base color of the eye, then I put a highlight in the eye after.

Then I lighten the lower part of the eye, then I put some additional highlight to make the eye look watery and appealing. After that, I add a cast shadow on the lower part of the upper eyelid

This is how to color a mouth first I set the base color of the mouth, then I put minimal shading in it. I usually shade inside the upper mouth with dark color and highlight only the outer part of the tongue.

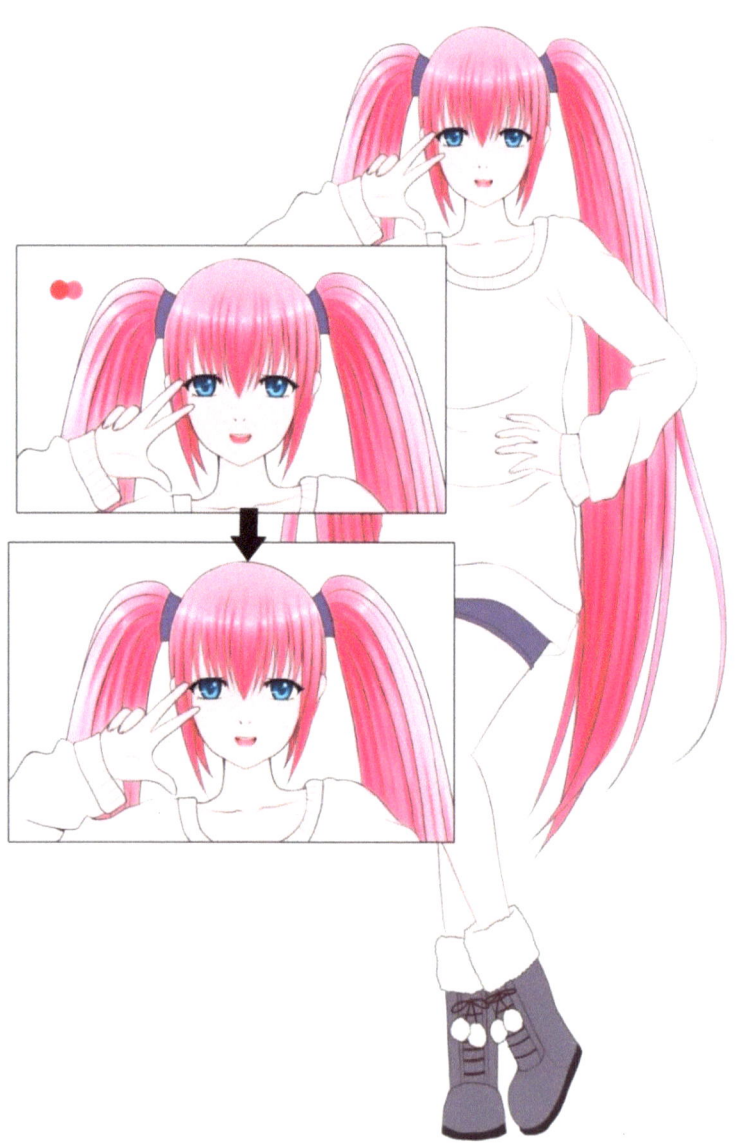

Now for skin shading first, select a color darker than the base color, then put some shades on the neck side of the face, armpit and near to the crotch area.

Then choose darker a color than the second shade, then put some shades on the area that you shade earlier.

Then finally lighten up some areas on the skin and this will make the finishing touches.

Now for shading the clothing use a soft, rounded brush, then brush the areas where folds exist and follow the contour of the cloth

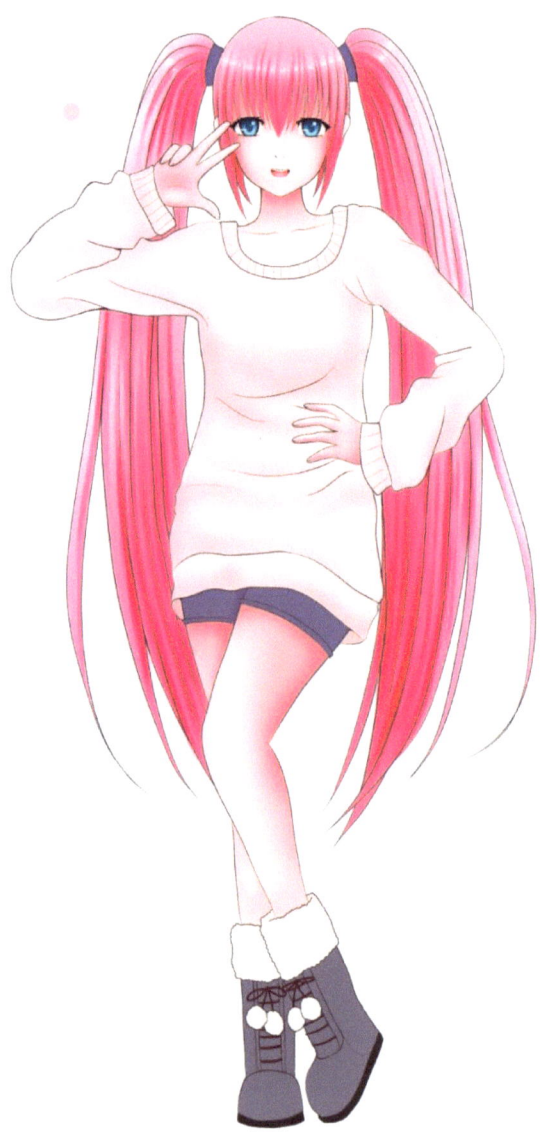

Then put some additional shades to make the detail stand out

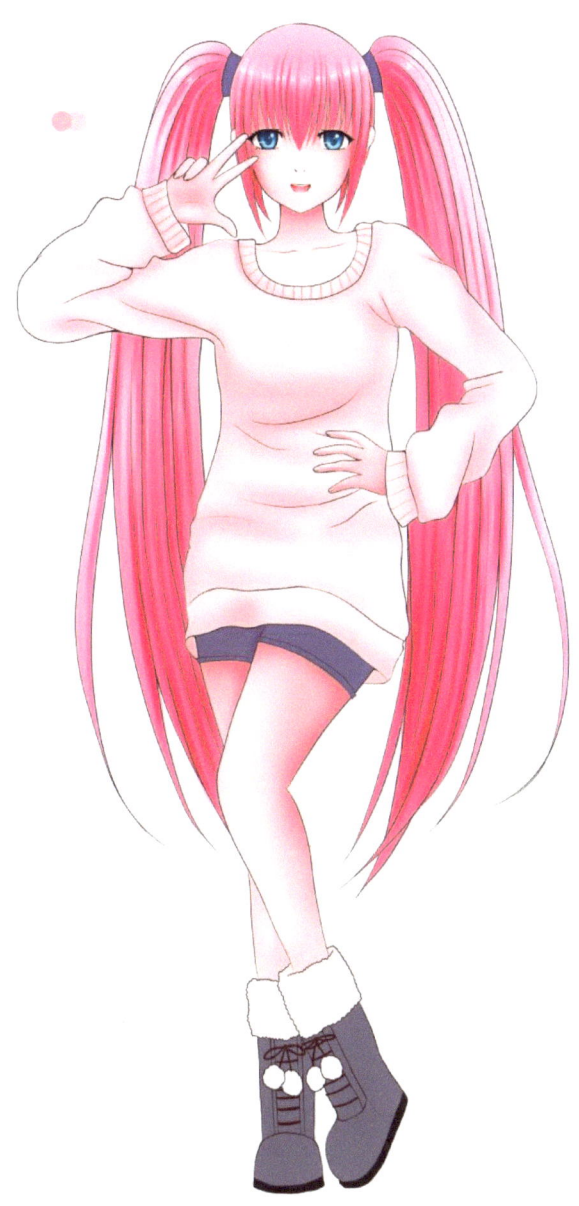

Then define the folds by adding darker shades then lighten up some of the areas of the cloth.

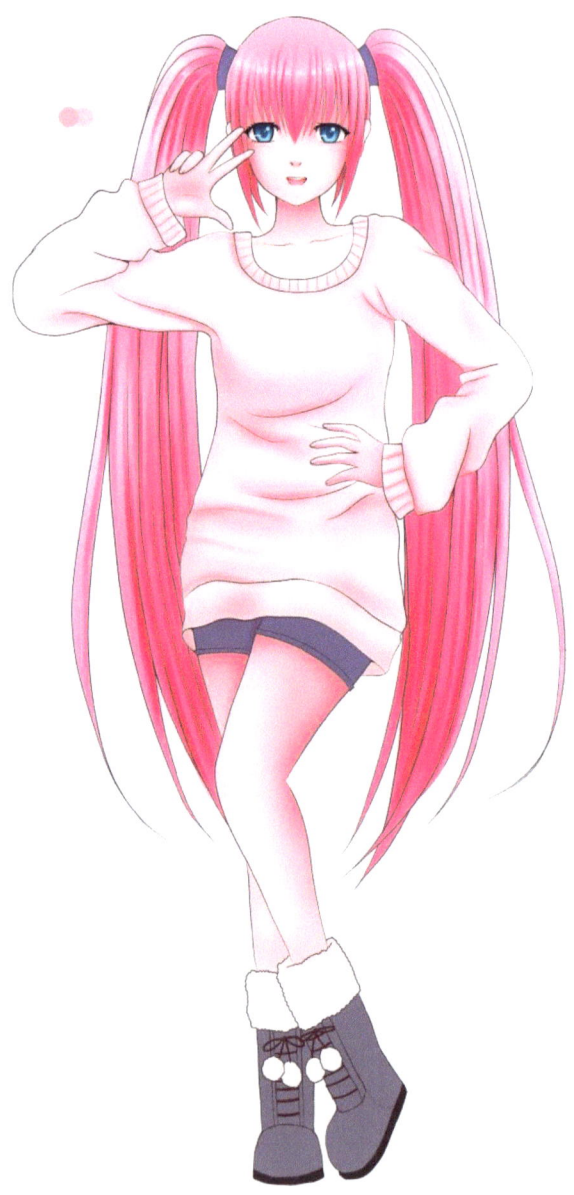

Then finally I put some details and shades on the shoes and done.

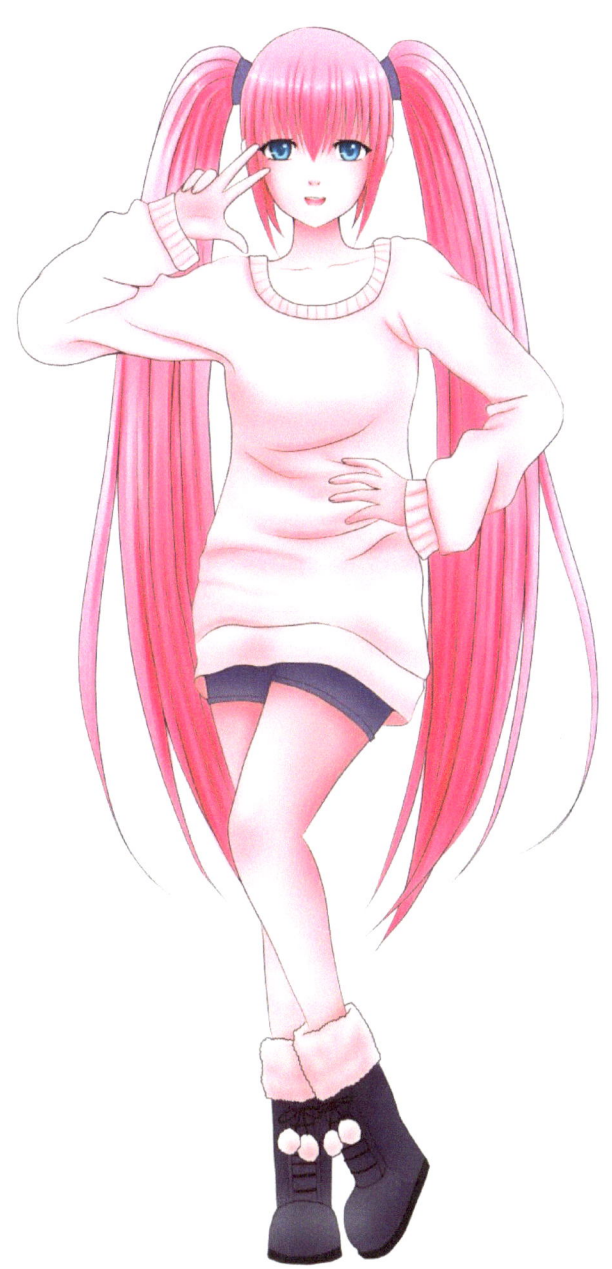

Author Bio

William T. Dela Peña Jr.

William T. Dela Pena Jr. was born in Tondo, Manila but he grew up in their province in Delfin Albano, Isabela. When he was a child his parents and his relatives were always getting mad at him, because of his unusual behavior. He is hyperactive and filled with curiosity in his surroundings. He always draws what he see and what he think and from there he discovered his passion for arts. During his school years, he earned a lot of rewards in art competitions that he joined

He tried to earn a B.S. degree in Information Technology, but unfortunately, he wasn't able to finish his course due to some reasons. Then he decided to go back in Manila and to work as a graphic artist. While he was working as a graphic artist, he spends his free time in drawing anime then his friends that are Otakus notice that he has a potential in drawing manga then his friend encourages him to get involved in manga industry and he started working as a freelance manga illustrator.

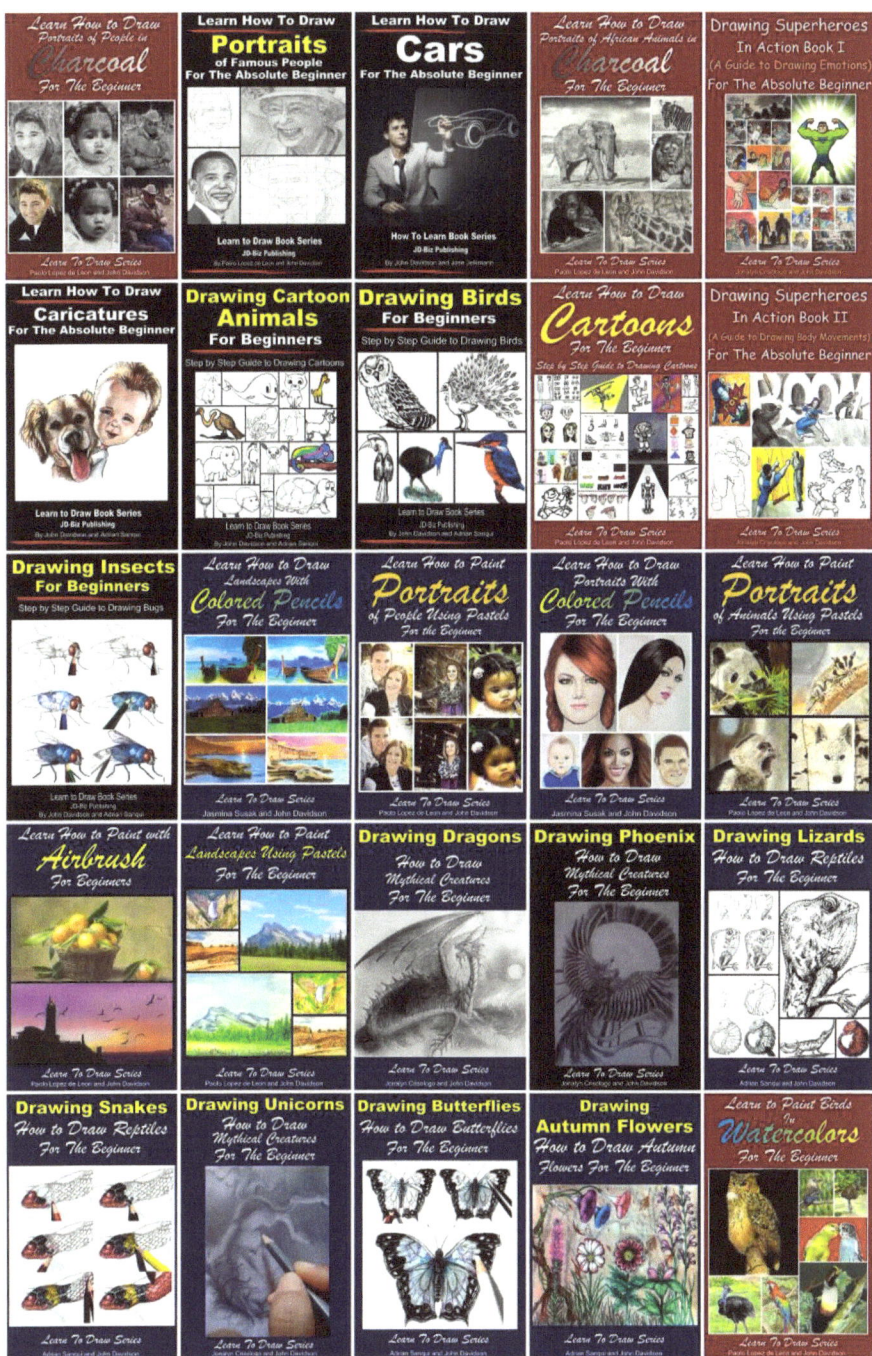

How to Draw Manga for the Beginner

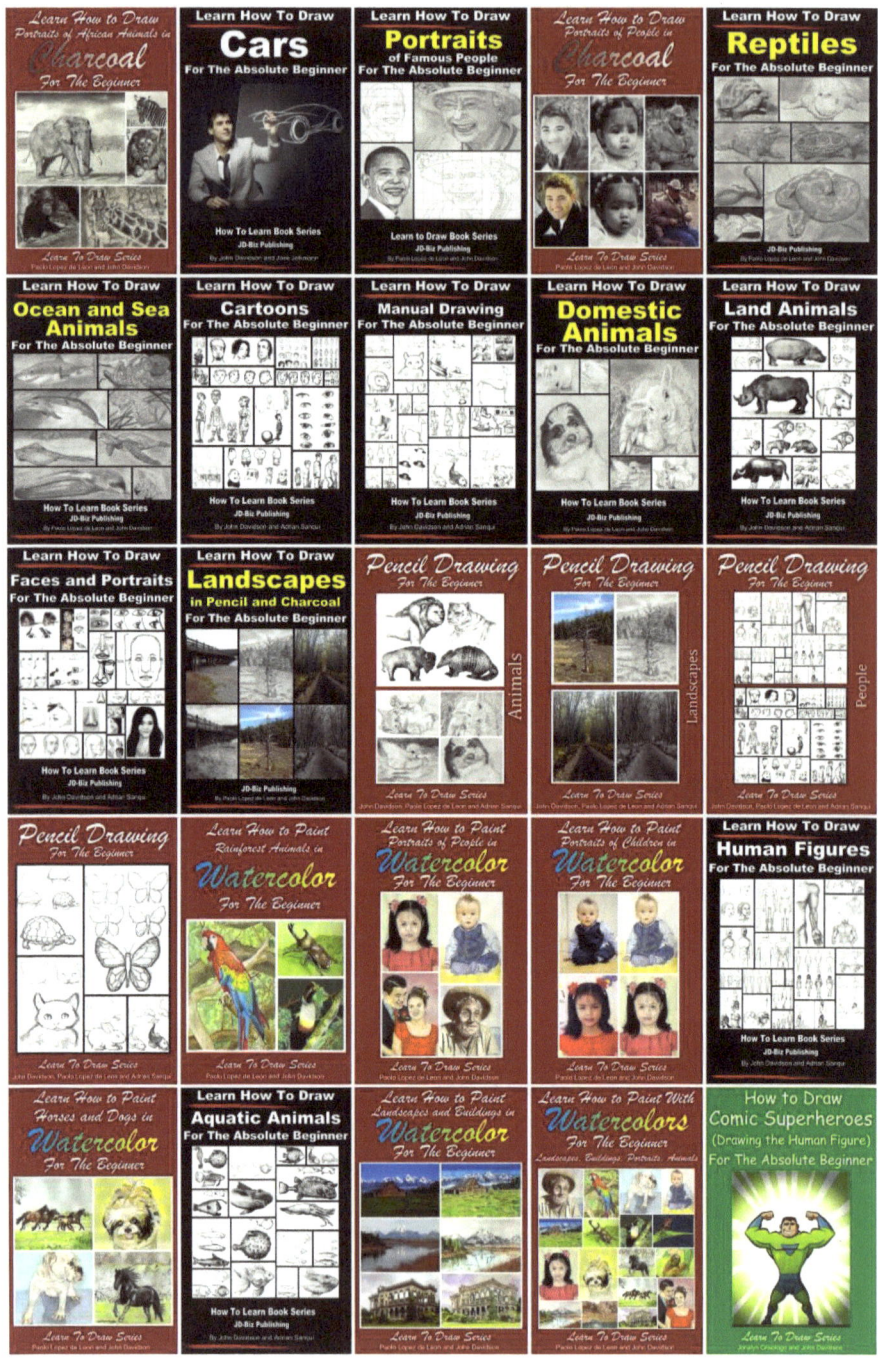

Publisher

JD-Biz Corp
P O Box 374
Mendon, Utah 84325
http://www.jd-biz.com/

www.ingramcontent.com/pod-product-compliance
Lightning Source LLC
Chambersburg PA
CBHW040831180526
45159CB00001B/150